W9-AMB-079

A Note from Mike

I wrote the first "Note from the Universe" 15 years ago because it was exactly what I most wanted to receive at the time—inspiration and reassurance from a source greater than myself. The Note was a hit. I was inspired and reassured, and subscribers wanted more. Looking back, I think the demonstration of writing as the Universe, as much as receiving an e-mail from the Universe as subscribers do, helps to create a space that allows us to feel cherished, essential, and guided.

On the pages within, we've chosen some of the all-time most popular and empowering Notes ever written and paired them with original, hand-drawn designs that beg to come alive with your own creative sharing. These images are now holding the space for you to revel in the truth of your magnificence and oneness with Source. As you lift pen or pencil, crayon or charcoal, paintbrush or marker to channel your higher self, trust that you will receive exactly what you most need.

Happy coloring! Happy inspiration! Happy everything!

About Mike

Mike Dooley is a former PriceWaterhouseCoopers international tax consultant turned entrepreneur, and founder of a philosophical Adventurers Club on the Internet that's now home to over 700,000 members from over 182 countries. His inspirational books emphasizing spiritual accountability have been published in 25 languages, and he was one of the featured teachers in the international phenomenon *The Secret*. Today Mike may be best known for his free Notes from the Universe e-mailings, social network postings, and his *New York Times* bestsellers *Infinite Possibilities* and *Leveraging the Universe*. Mike lives what he teaches, traveling internationally speaking on life, dreams, and happiness.

Find out more at **tut.com**

About Gina

Gina is a new addition to Mike's team at TUT's Adventurers Club, contributing her dual talents as both a graphic designer and front-end web developer.

Before relocating to Orlando, Florida, Gina was raised in Indianapolis, Indiana, where she earned her B.S. in media arts and science, developed a love for local artistry, and began cultivating her skills as a visual artist. She gains inspiration from family, music, traveling, and the culinary world.

www.ginairie.com

© tut.com

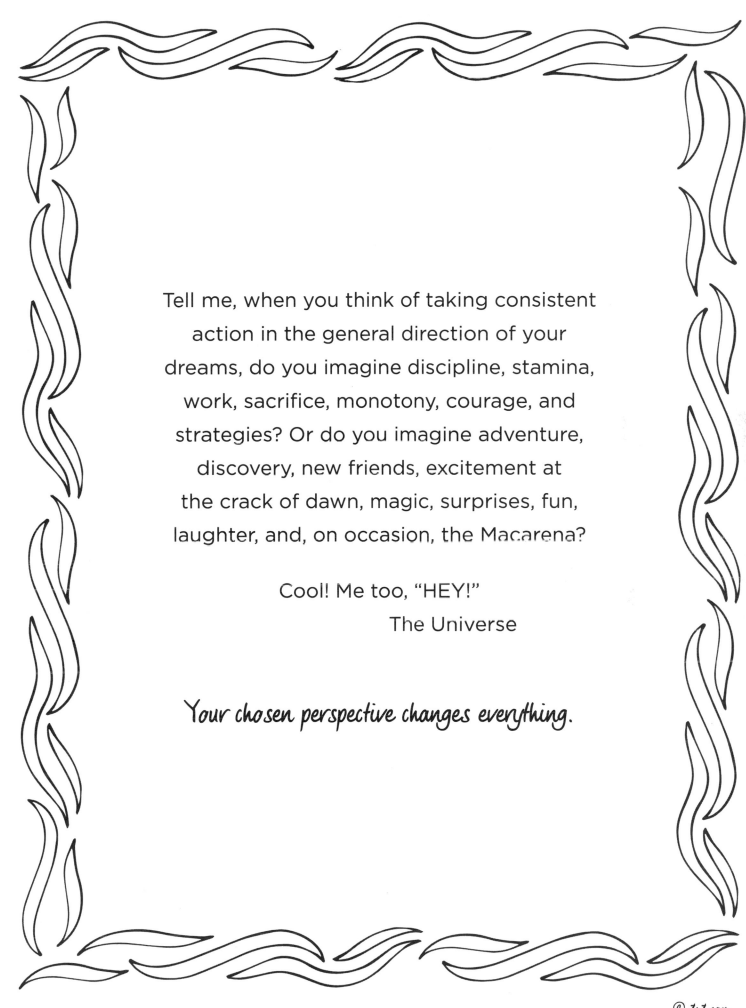

Tell me, when you think of taking consistent action in the general direction of your dreams, do you imagine discipline, stamina, work, sacrifice, monotony, courage, and strategies? Or do you imagine adventure, discovery, new friends, excitement at the crack of dawn, magic, surprises, fun, laughter, and, on occasion, the Macarena?

Cool! Me too, "HEY!"

The Universe

Your chosen perspective changes everything.

© tut.com

Young souls look to secrets, rites, and rituals.

Advanced souls look to science,
math, and evidence.

And old souls look within.

Look within,
 The Universe

Aren't young souls cute?

© tut.com

All you want LIES within you

© tut.com

© tut.com

There is a purpose, a plan, and a
reason for all things. What doesn't
make sense, will make sense.

You are exactly where you should be.
Your challenges are what they should be.
Your rewards are what they should be.
And the best is yet to come.

Tallyho,
 The Universe

A toast to life... to you... to us...

© tut.com

Always trust your dreams.

They've chosen you as much
as you've chosen them.

Tallyho,
 The Universe

And it really ticked off all the other dreams, too.

© tut.com

Always trust your DREAMS

© tut.com

© tut.com

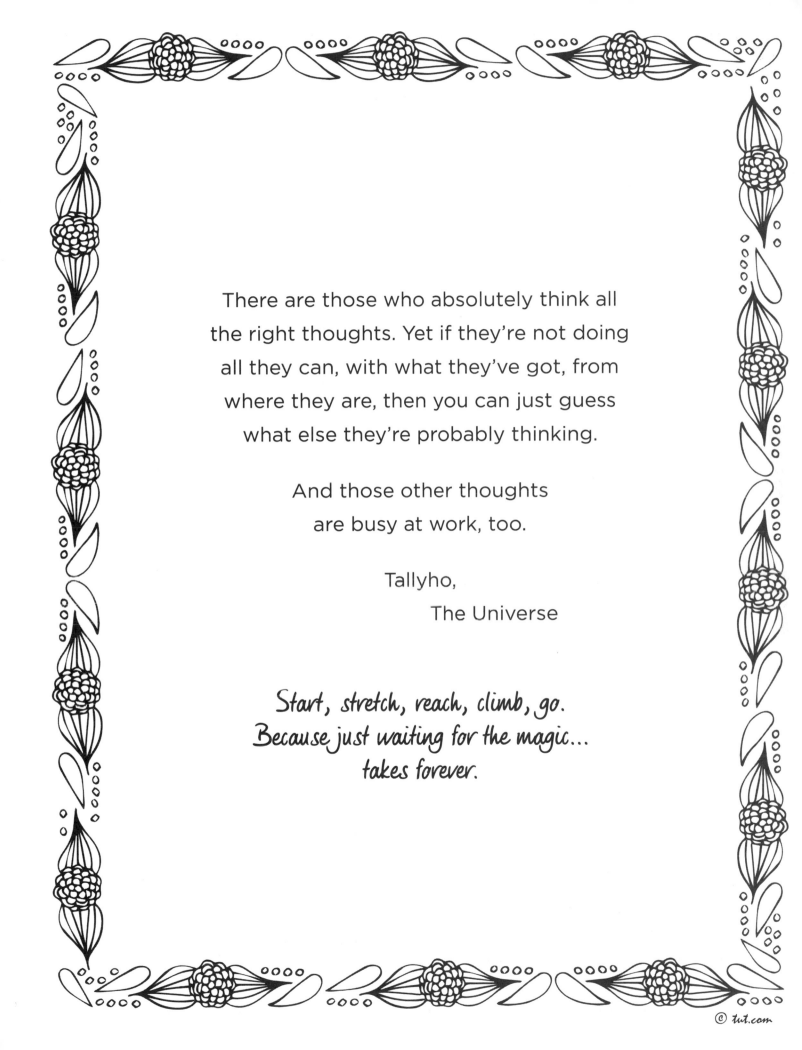

There are those who absolutely think all the right thoughts. Yet if they're not doing all they can, with what they've got, from where they are, then you can just guess what else they're probably thinking.

And those other thoughts are busy at work, too.

Tallyho,

The Universe

Start, stretch, reach, climb, go.
Because just waiting for the magic...
takes forever.

© tut.com

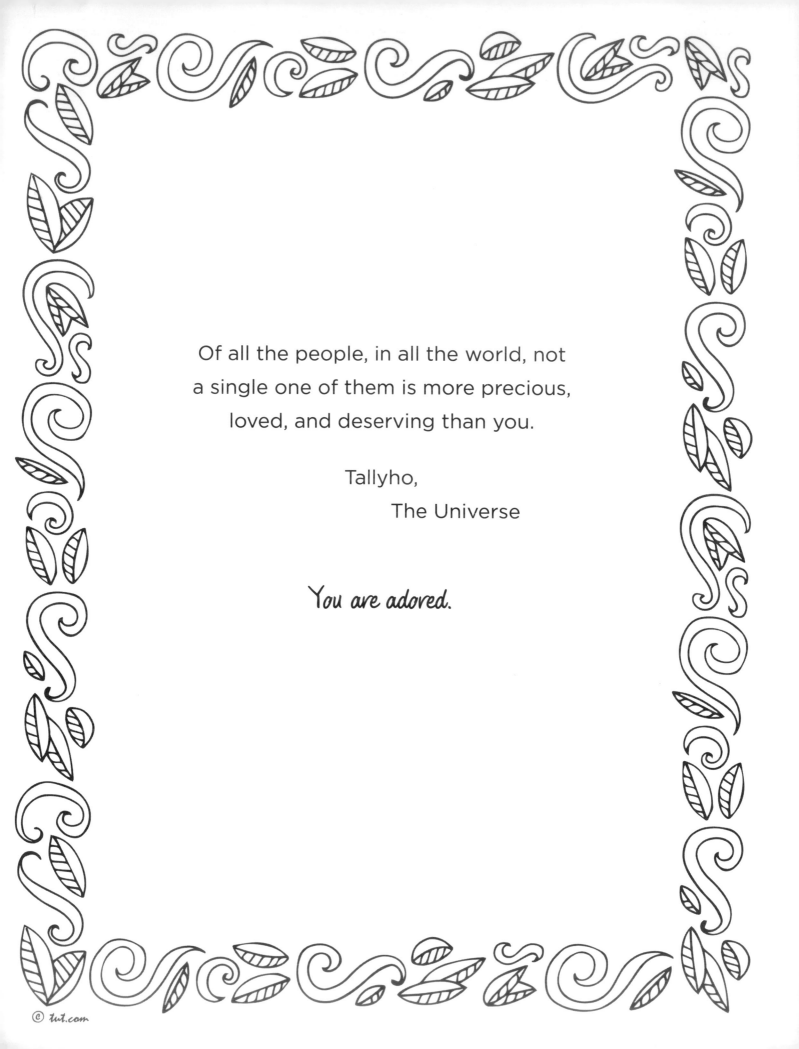

Of all the people, in all the world, not
a single one of them is more precious,
loved, and deserving than you.

Tallyho,
 The Universe

You are adored.

© tut.com

© tut.com

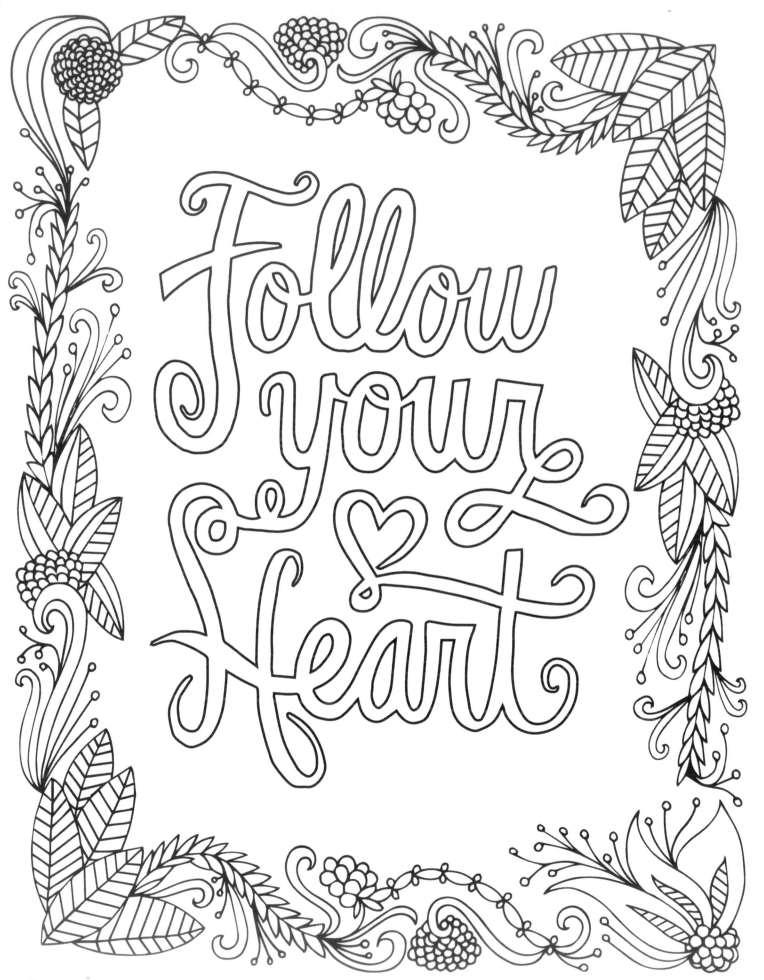

© tut.com

Always follow your heart; unless it's been broken, then you must lead it.

Back into love,

The Universe

Did you know that hearts are never too big to mend, too small to rebound, or too tired to love?

© tut.com

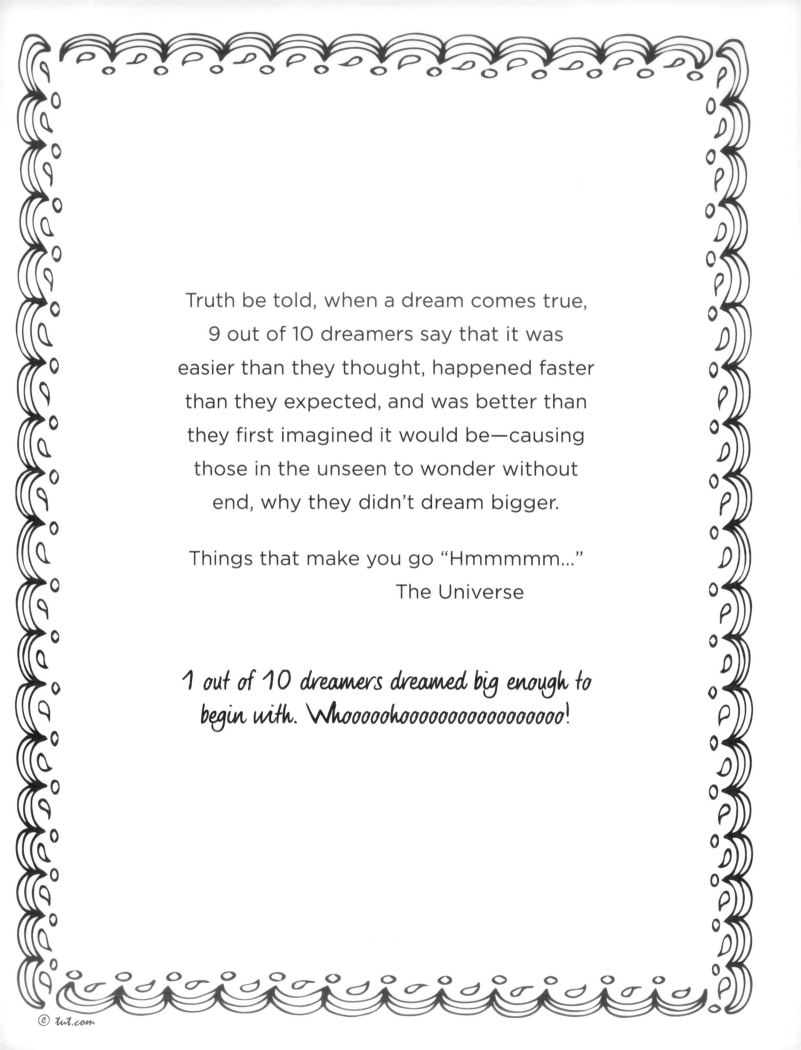

Truth be told, when a dream comes true,
9 out of 10 dreamers say that it was
easier than they thought, happened faster
than they expected, and was better than
they first imagined it would be—causing
those in the unseen to wonder without
end, why they didn't dream bigger.

Things that make you go "Hmmmmm..."
The Universe

1 out of 10 dreamers dreamed big enough to
begin with. Whoooohoooooooooooooooooooo!

© tut.com

© tut.com

© tut.com

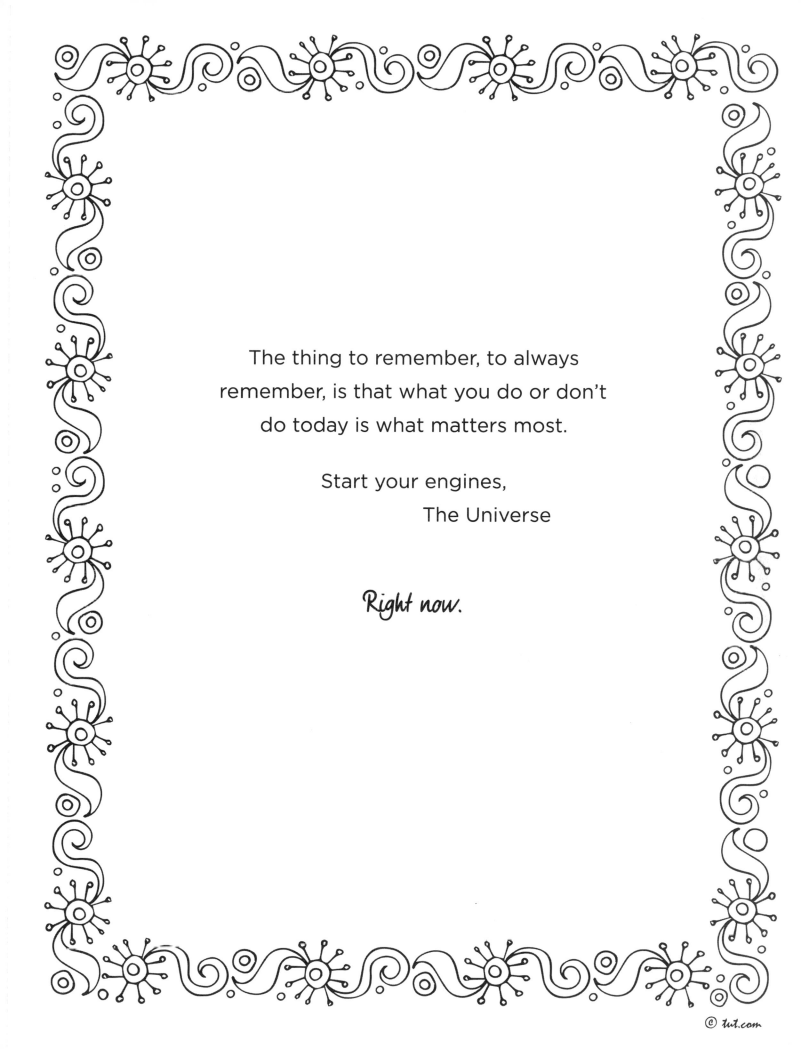

The thing to remember, to always remember, is that what you do or don't do today is what matters most.

Start your engines,
The Universe

Right now.

© tut.com

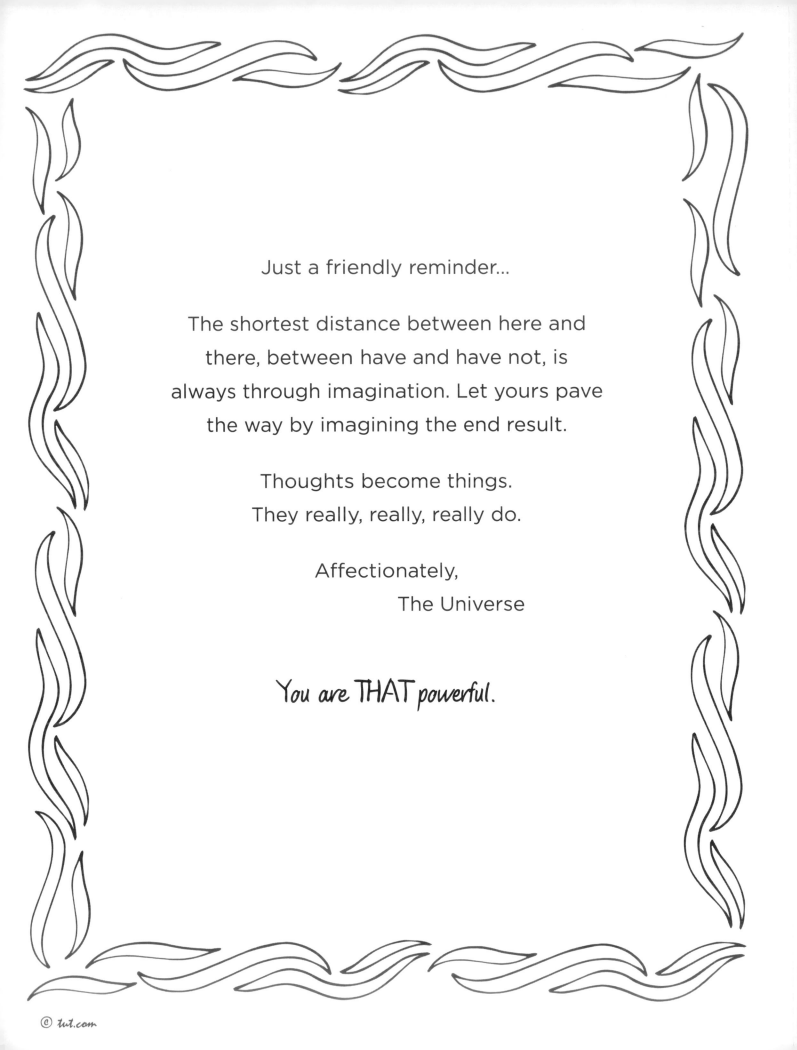

Just a friendly reminder...

The shortest distance between here and
there, between have and have not, is
always through imagination. Let yours pave
the way by imagining the end result.

Thoughts become things.
They really, really, really do.

Affectionately,
 The Universe

You are THAT powerful.

© tut.com

THOUGHTS BECOME THINGS

© tut.com

© tut.com

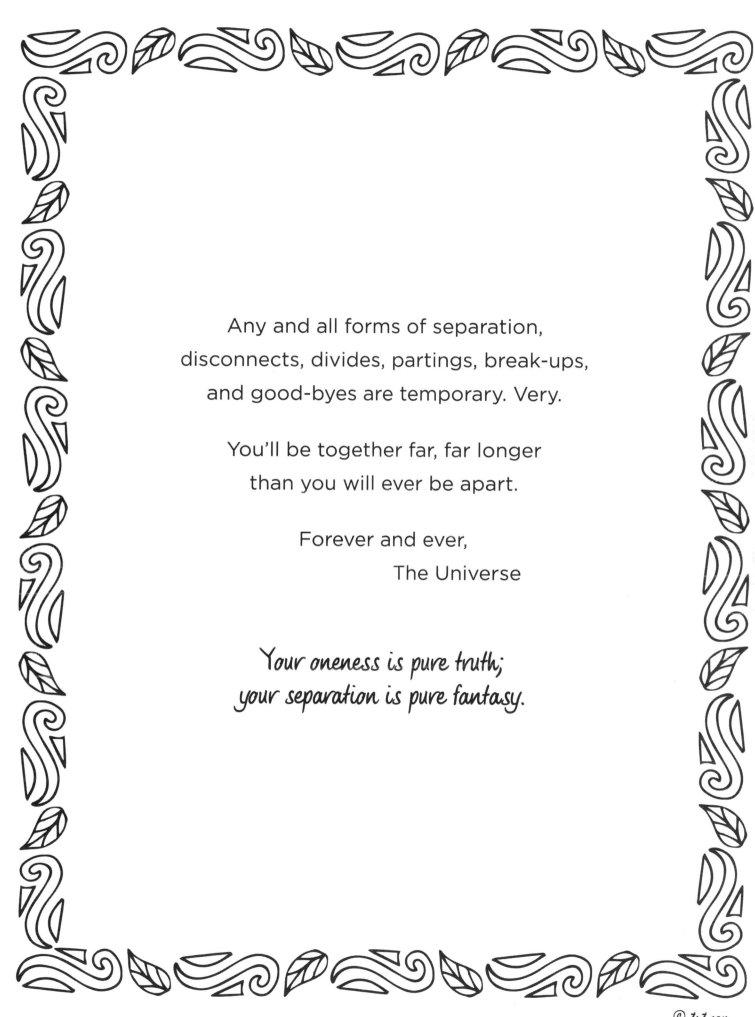

Any and all forms of separation,
disconnects, divides, partings, break-ups,
and good-byes are temporary. Very.

You'll be together far, far longer
than you will ever be apart.

Forever and ever,

 The Universe

Your oneness is pure truth;
your separation is pure fantasy.

© tut.com

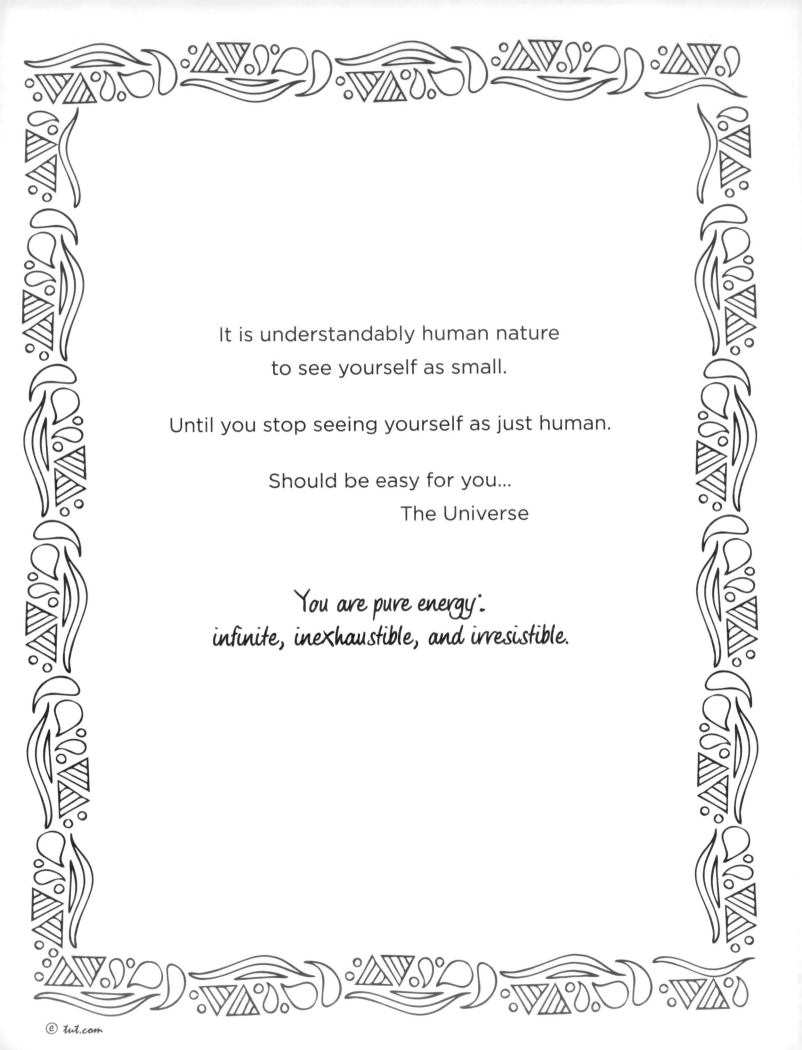

It is understandably human nature
to see yourself as small.

Until you stop seeing yourself as just human.

Should be easy for you...
The Universe

You are pure energy:
infinite, inexhaustible, and irresistible.

© tut.com

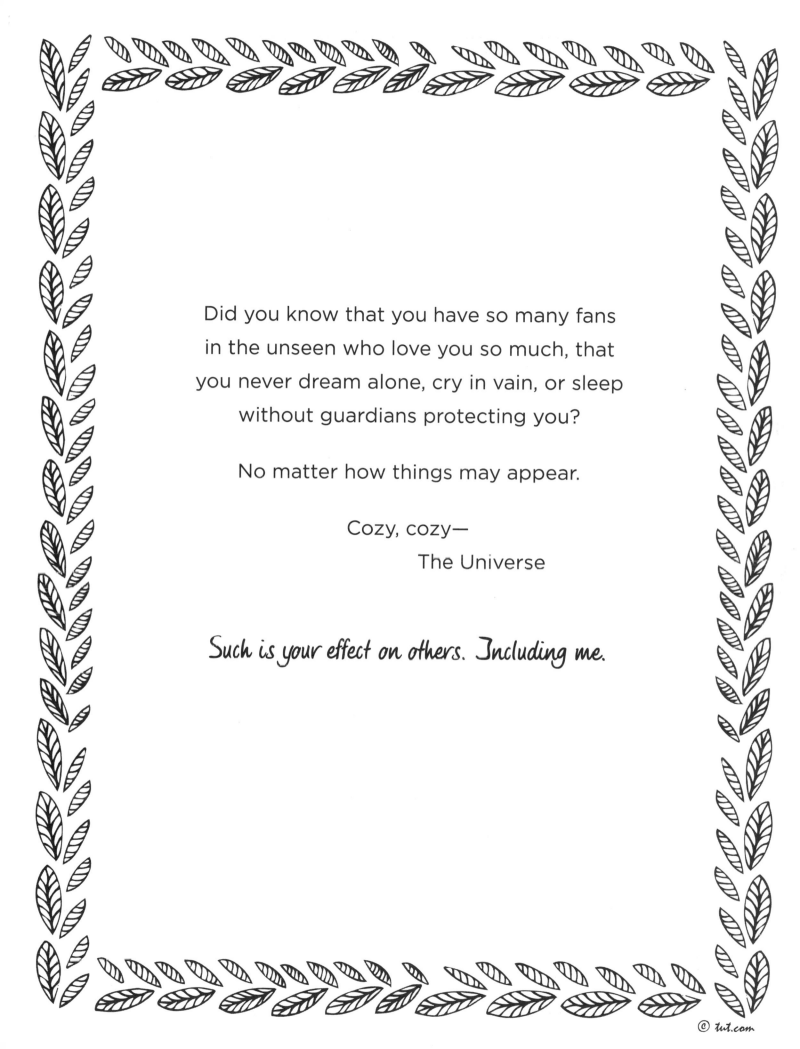

Did you know that you have so many fans
in the unseen who love you so much, that
you never dream alone, cry in vain, or sleep
without guardians protecting you?

No matter how things may appear.

Cozy, cozy—

The Universe

Such is your effect on others. Including me.

© tut.com

All you have to do is be. Be yourself.

There's nothing to prove. And there's no one to please who isn't already over the moon with joy at how well you've done and with who you've become.

I am,
 The Universe

Rock on, maestro.

© tut.com

© tut.com

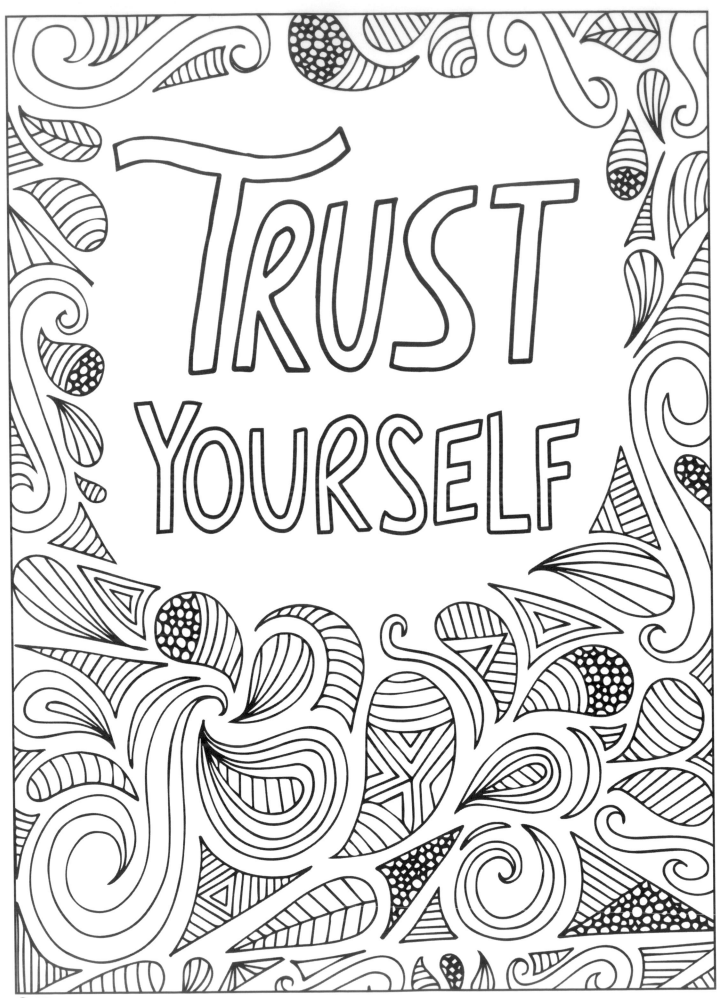

© tut.com

Not what you should do, but what you want to do; let this be your guiding light, forevermore.

I see you shining,
The Universe

Trust yourself, as much as you trust me.

© tut.com

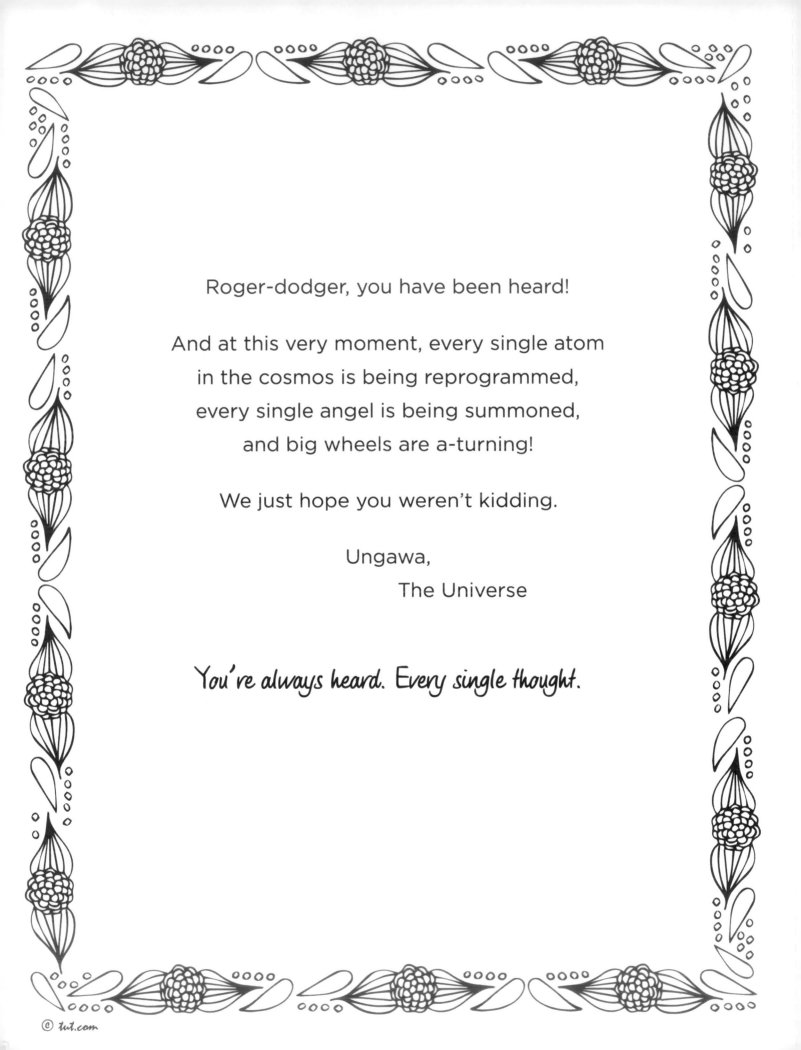

Roger-dodger, you have been heard!

And at this very moment, every single atom
in the cosmos is being reprogrammed,
every single angel is being summoned,
and big wheels are a-turning!

We just hope you weren't kidding.

Ungawa,
 The Universe

You're always heard. Every single thought.

© tut.com

THE
UNIVERSE
IS
LISTENING

© tut.com

DREAM, BELIEVE, SHOW UP.

© tut.com

Now! Go! Stake your claim! Hold out your hands. Move, get ready, give thanks. Imagine, and let go. Act, and have faith. Persist. Do what you can, when you can, all you can. Because never again, not in a million years, not over 10,000 lifetimes, will you ever again be as close as you are today.

Ungawa,
 The Universe

Use your soul powwa!

© tut.com

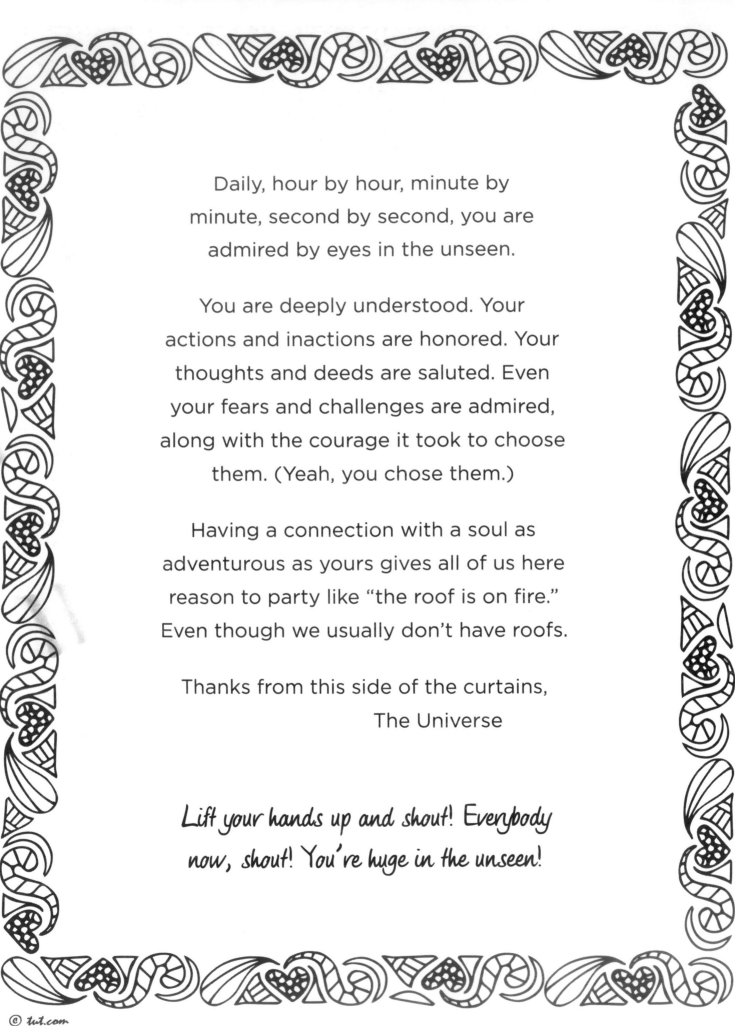

Daily, hour by hour, minute by minute, second by second, you are admired by eyes in the unseen.

You are deeply understood. Your actions and inactions are honored. Your thoughts and deeds are saluted. Even your fears and challenges are admired, along with the courage it took to choose them. (Yeah, you chose them.)

Having a connection with a soul as adventurous as yours gives all of us here reason to party like "the roof is on fire." Even though we usually don't have roofs.

Thanks from this side of the curtains,
The Universe

Lift your hands up and shout! Everybody now, shout! You're huge in the unseen!

© tut.com

© tut.com

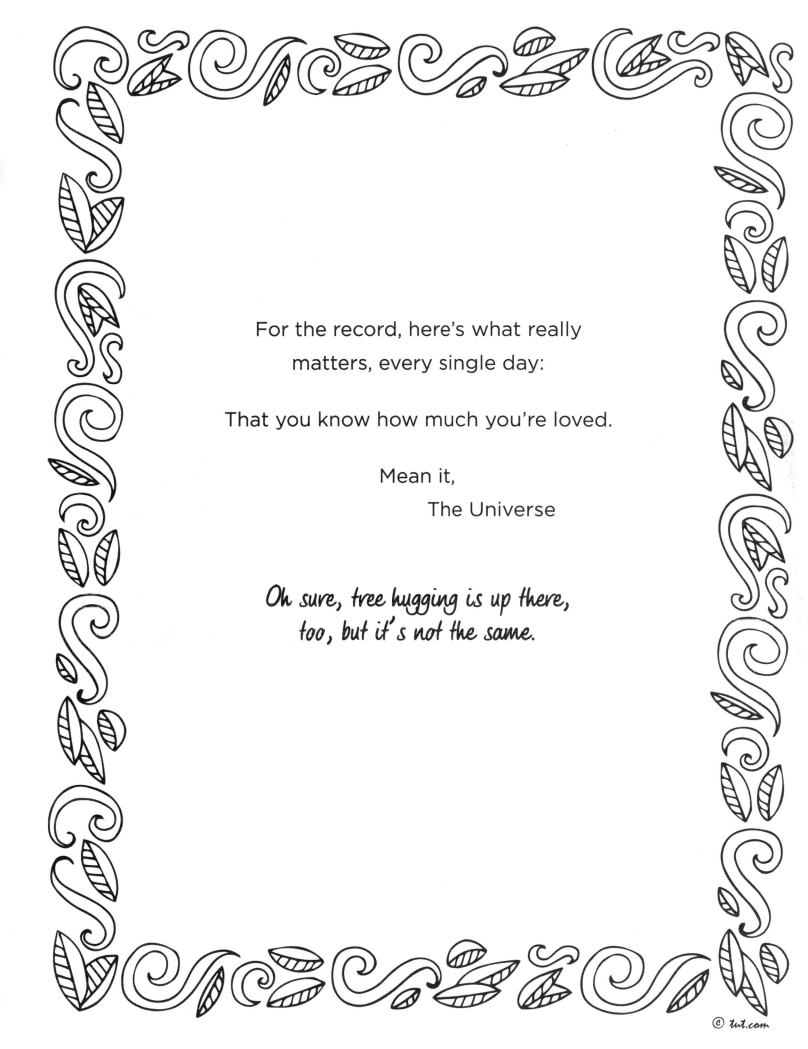

For the record, here's what really matters, every single day:

That you know how much you're loved.

Mean it,

The Universe

Oh sure, tree hugging is up there, too, but it's not the same.

© tut.com

The thing about success is that she often arrives at such a late hour that only the oddballs, freaks, and nuts (you know, the ones who continued believing in spite of all worldly evidence to the contrary) remain to greet her.

A little weird is good,
 The Universe

Well, she doesn't have to arrive so late, but sometimes that's how long it takes before people stop fretting about whether or not she ever will.

© tut.com

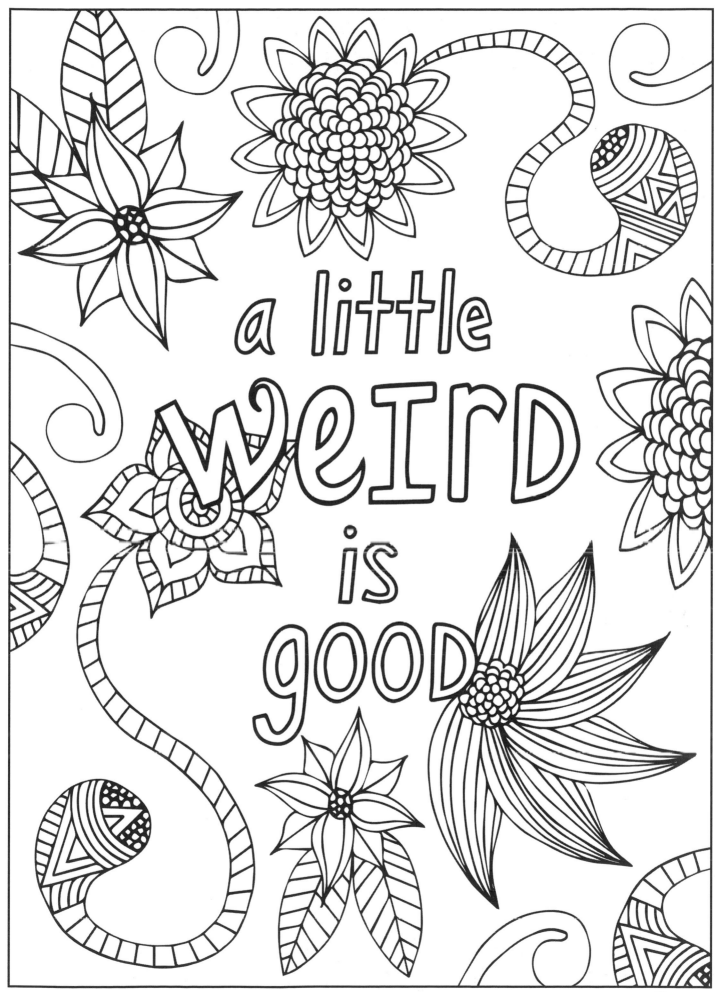

a little WEIRD is good

© tut.com

© tut.com

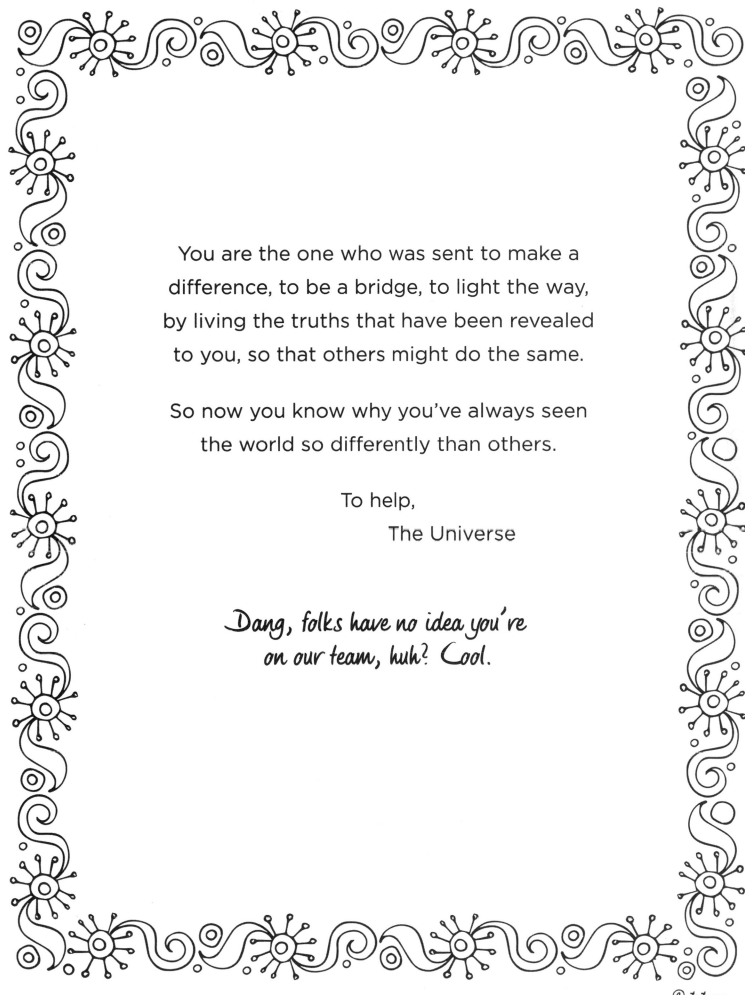

You are the one who was sent to make a difference, to be a bridge, to light the way, by living the truths that have been revealed to you, so that others might do the same.

So now you know why you've always seen the world so differently than others.

To help,
The Universe

Dang, folks have no idea you're on our team, huh? Cool.

© tut.com

Do you know what "unlimited" means?

It means you decide—everything.

Whoa,
 The Universe

Dang! You've got it made.

© tut.com

© tut.com

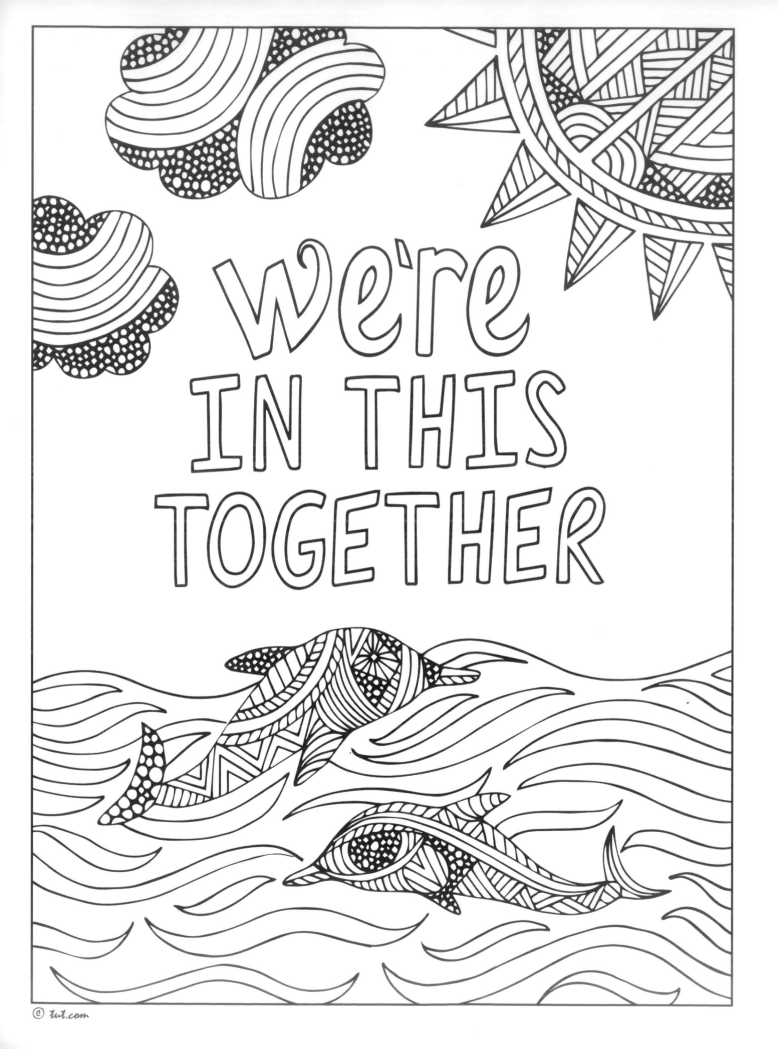

© tut.com

There are a million reasons why any
dream might be considered irrational,
unreasonable, and a silly waste of time.

On the other hand, I can think of one that blows
'em all out of the water... we're in this together.

Hup 1, Hup 2—

The Universe

There's no breath you take, or step
you make, that we don't share.

© tut.com

Relax. Breathe in deep. Hold it. Let it out.
Loosen your shoulders. Smile. Close
your eyes. And you'll be surprised at
how many voices you'll hear, whispering
sweet encouragement into your ear.

Kissey, kissey, you can do it—
The Universe

Be still, be calm, and listen. You'll
find there's nowhere you can't go, no
challenge you can't master, and no reason
whatsoever that you can't have it all.

© tut.com

BREATHE
DEEP

© tut.com

© tut.com

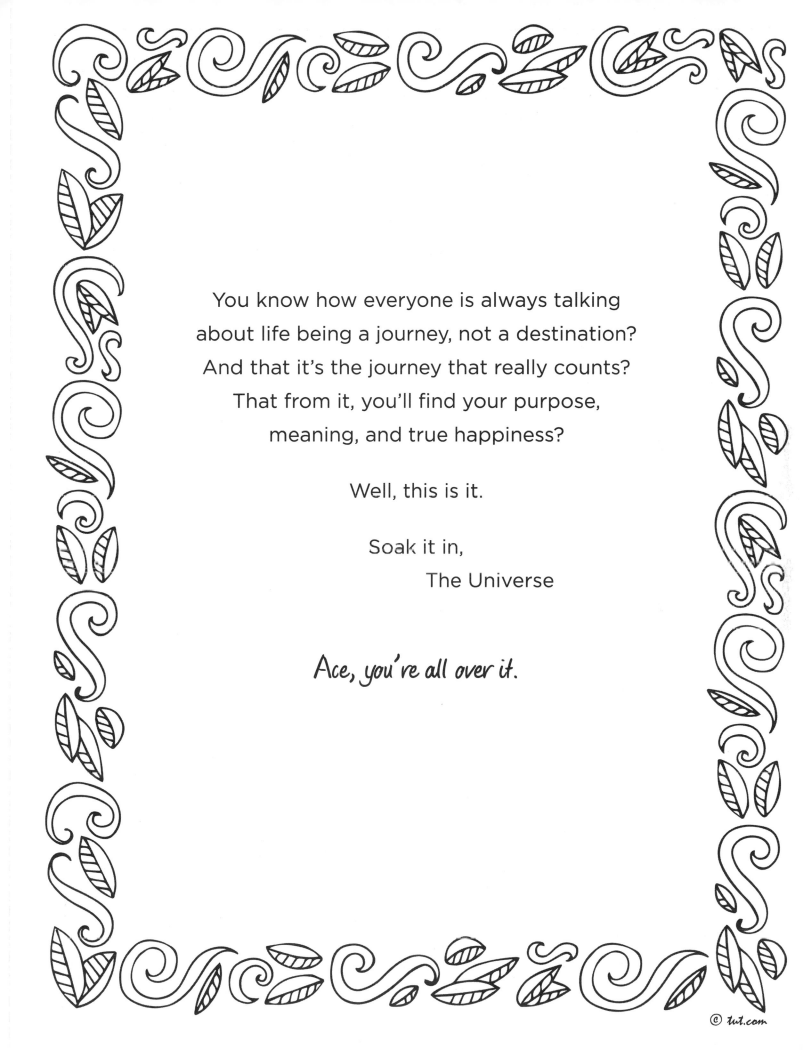

You know how everyone is always talking
about life being a journey, not a destination?
And that it's the journey that really counts?
That from it, you'll find your purpose,
meaning, and true happiness?

Well, this is it.

Soak it in,

The Universe

Ace, you're all over it.

© tut.com

Of course you don't have to visualize!!

Nor do you have to wear matching clothes,
chew food with your mouth closed,
sleep enough each night, brush your teeth,
bathe regularly, speak in complete sentences,
use proper grammar, run spell-check,
zip up your fly, or pay your bills on time.

But really, wouldn't you be mortified
if anyone found out?

I know I would...
The Universe

Now, if you were going to do just one of
those things every single day... Visualize.

© tut.com

Visualize!

© tut.com

© tut.com

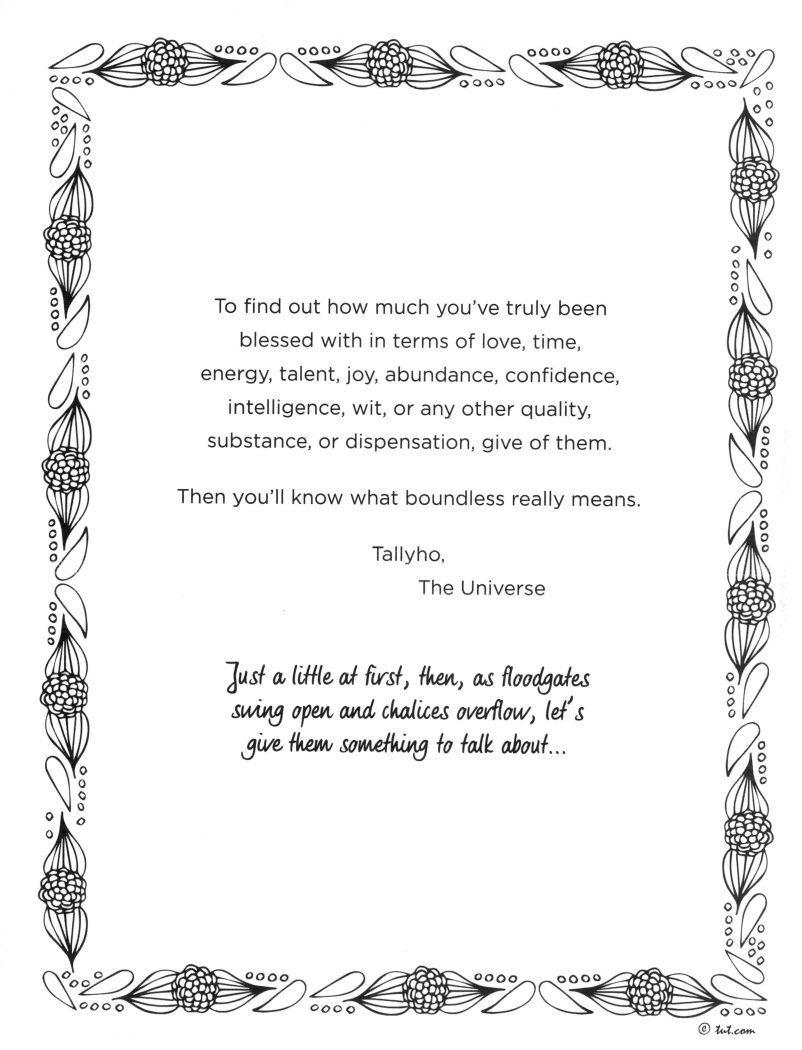

To find out how much you've truly been
blessed with in terms of love, time,
energy, talent, joy, abundance, confidence,
intelligence, wit, or any other quality,
substance, or dispensation, give of them.

Then you'll know what boundless really means.

Tallyho,
 The Universe

Just a little at first, then, as floodgates swing open and chalices overflow, let's give them something to talk about...

© tut.com

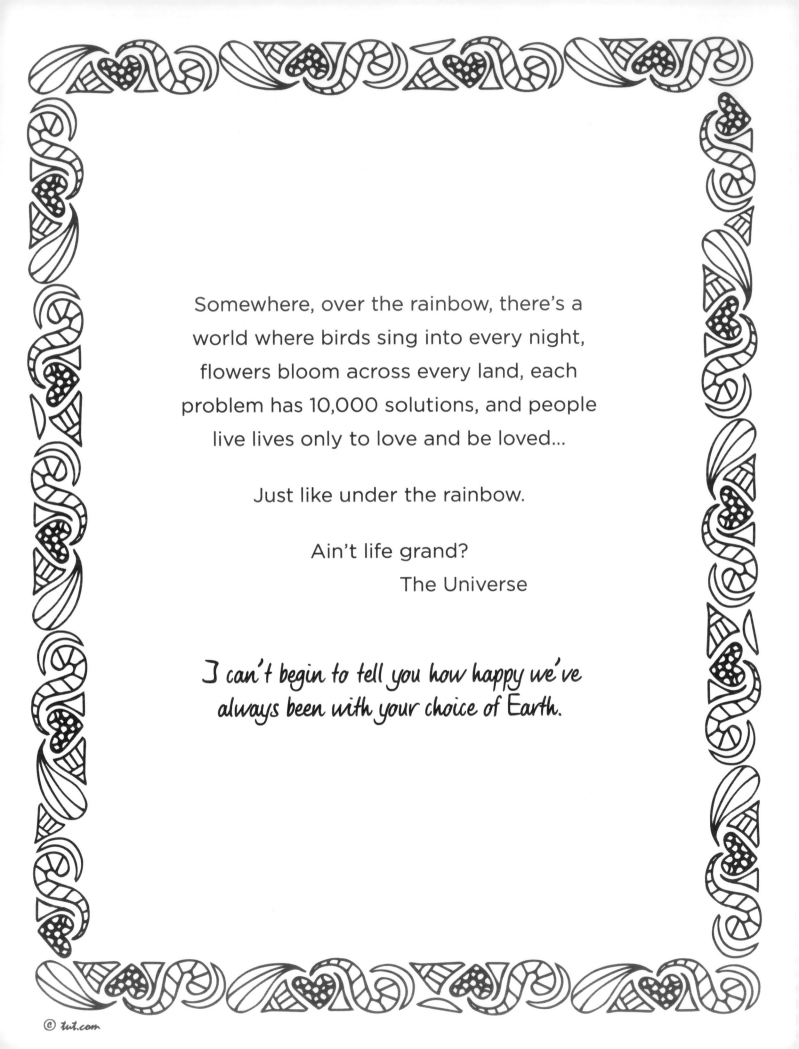

Somewhere, over the rainbow, there's a world where birds sing into every night, flowers bloom across every land, each problem has 10,000 solutions, and people live lives only to love and be loved...

Just like under the rainbow.

Ain't life grand?
The Universe

I can't begin to tell you how happy we've always been with your choice of Earth.

© tut.com

© tut.com

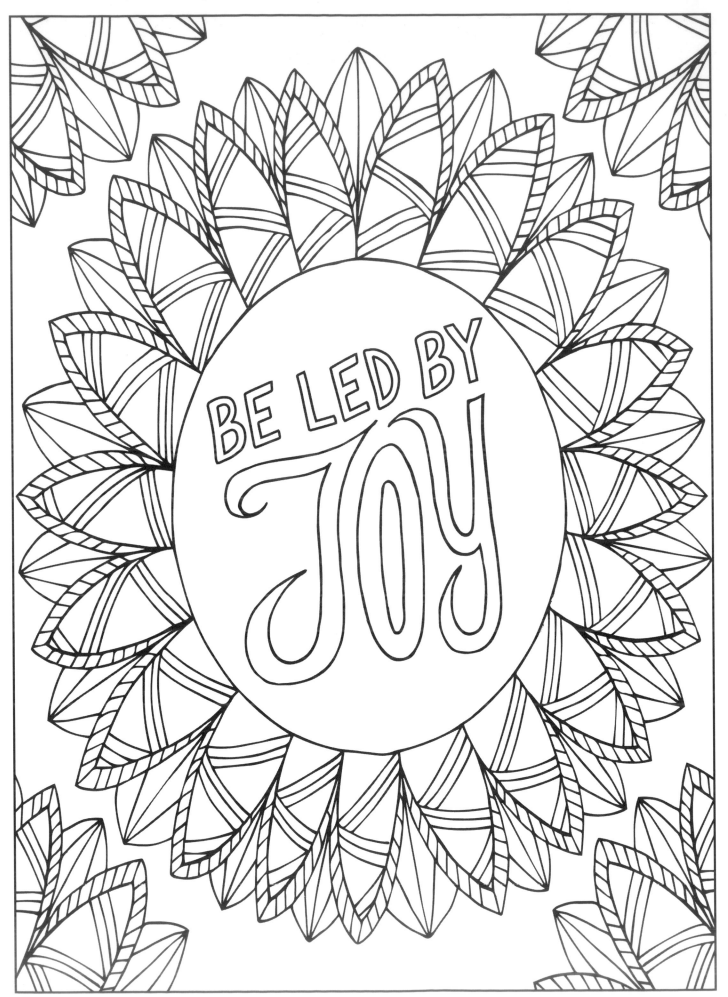

© tut.com

Be led by joy.

It's the whole point.

Tallyho,
 The Universe

Remember, before this entire adventure began, you once asked me to remind you of this? You asked that I time it right before the floodgates opened, so that you could stay grounded. You were studying at the prestigious Bent Light University... in the Ph.D. program... on a Hula-Hoop scholarship. "Go Illuminators!"

© tut.com

Sometimes, when you're feeling your lowest, the real you is summoned.

And you understand, maybe for the first time ever, how grand you are, because you discover that vulnerable doesn't mean powerless, scared doesn't mean lacking in beauty, and uncertainty doesn't mean that you're lost.

These realizations alone will set you on a journey that will take you far beyond what you used to think of as extraordinary.

There is always a bright side,
The Universe

Don't disguise your tears, don't hide your sadness, don't be afraid to find out who you really are. Because in those fleeting moments you'll summon such beauty and strength that, in no time at all, you'll fully grasp exactly why you're so gossiped about here in the unseen.

© tut.com

THERE IS ALWAYS A BRIGHT SIDE

© tut.com

© tut.com

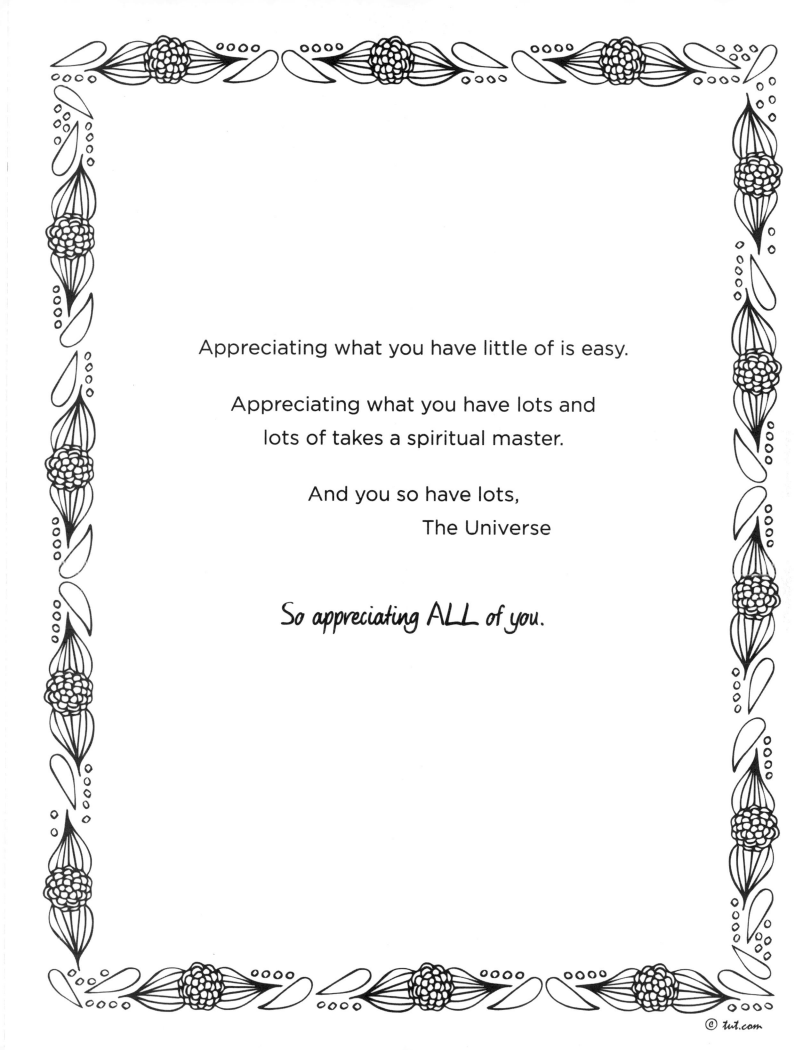

Appreciating what you have little of is easy.

Appreciating what you have lots and
lots of takes a spiritual master.

And you so have lots,
The Universe

So appreciating ALL of you.

© tut.com

This year will not be just another year.

It's the absolute richest I've ever imagined,
with the most possibilities I've ever offered,
for the coolest people I've ever known
to do the greatest things ever done.

Set the bar high,
 The Universe

This year is yours, baby.

© tut.com

Set
THE
BAR
HIGH

© tut.com

© tut.com

When you love who you are, you
become much more lovable.

Not that that's why I love you.

Love you,
 The Universe

*I love you, for no reason.
Not that there aren't millions.
Now, after three mind-expanding
tangents, please reread the first line.*

© tut.com

Some angels choose cleverly disguised
lives in time and space, just to help folks
get past judging by appearances.

No, they're not much to look at, listen to, or
dance with, and most would never guess
they're angels... but that's the point.

Every soul is beautiful,
The Universe

Some even come as rappers, late-night
radio personalities, or billionaires!

© tut.com

every
SOUL
is
beautiful

© tut.com

© tut.com

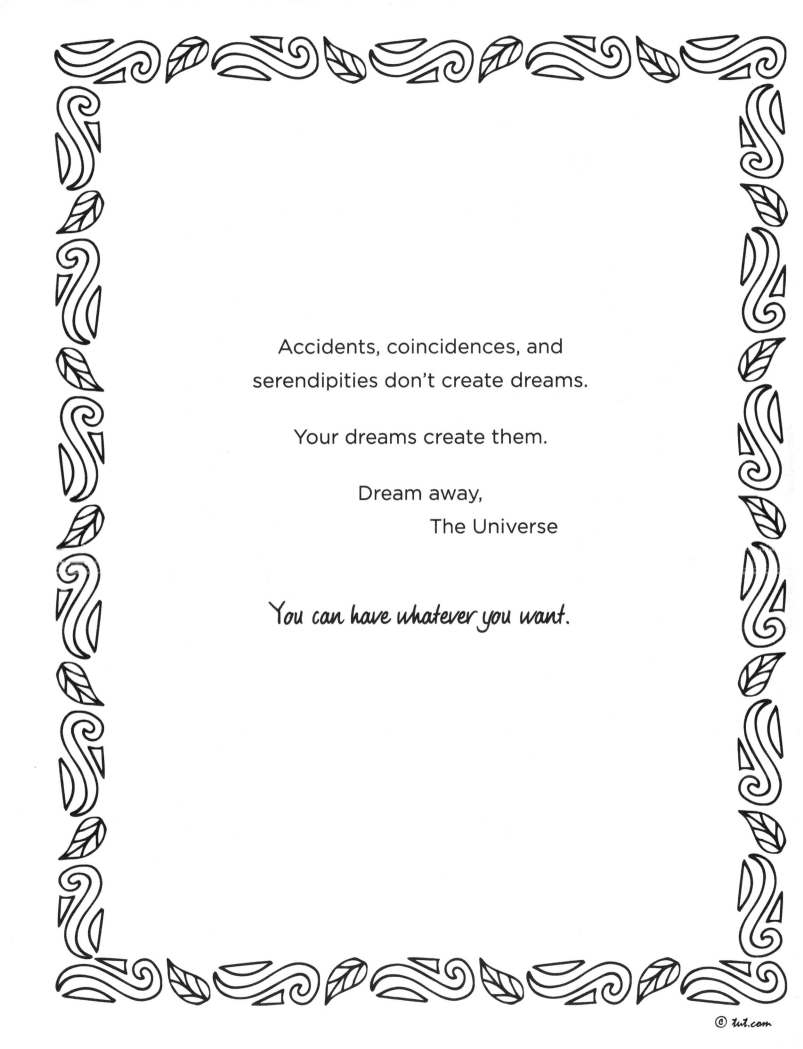

Accidents, coincidences, and
serendipities don't create dreams.

Your dreams create them.

Dream away,
The Universe

You can have whatever you want.

© tut.com

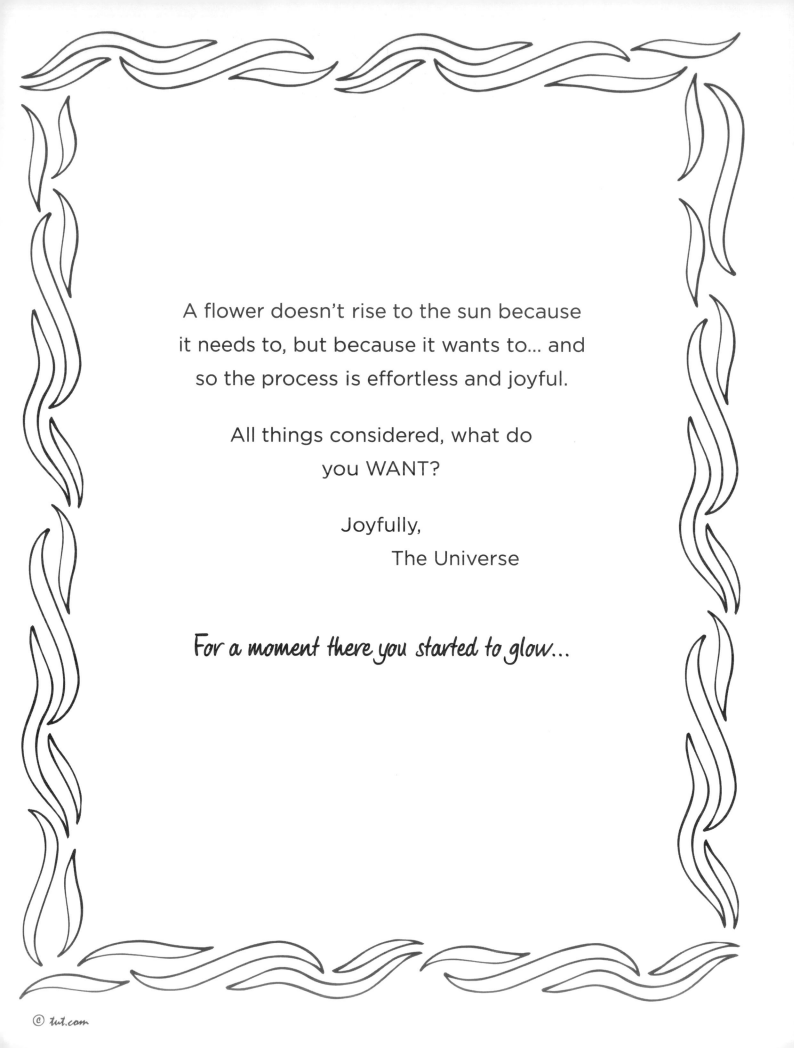

A flower doesn't rise to the sun because
it needs to, but because it wants to... and
so the process is effortless and joyful.

All things considered, what do
you WANT?

Joyfully,

The Universe

For a moment there you started to glow...

© tut.com

Be Joyful

© tut.com

© tut.com

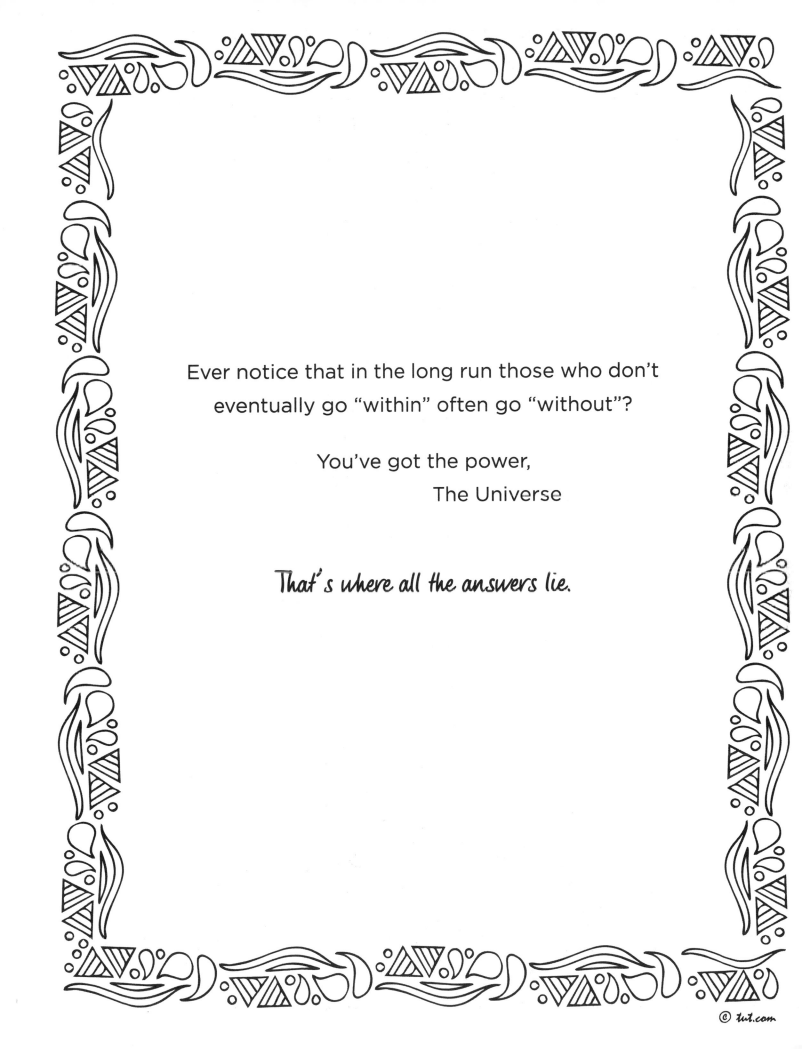

Ever notice that in the long run those who don't eventually go "within" often go "without"?

You've got the power,

The Universe

That's where all the answers lie.

© tut.com

Happiness always returns.

You know, in case you should
ever sense its absence.

Tallyho,
The Universe

Partly, because while it's away, it misses
you even more than you miss it.

© tut.com

© tut.com

Perhaps the greatest of all illusions is that life could somehow be better than it already is.

You've got it made,

The Universe

Precisely, your life.

© tut.com

You just never know who in the crowd,
standing beside you in line or passing you
in the street, might be raised in spirit, or
even lifted from despair, by the kindness in
your glance or the comfort of your smile.

But they may never forget.

Supersize me,
 The Universe

It takes so little.

© tut.com

© tut.com

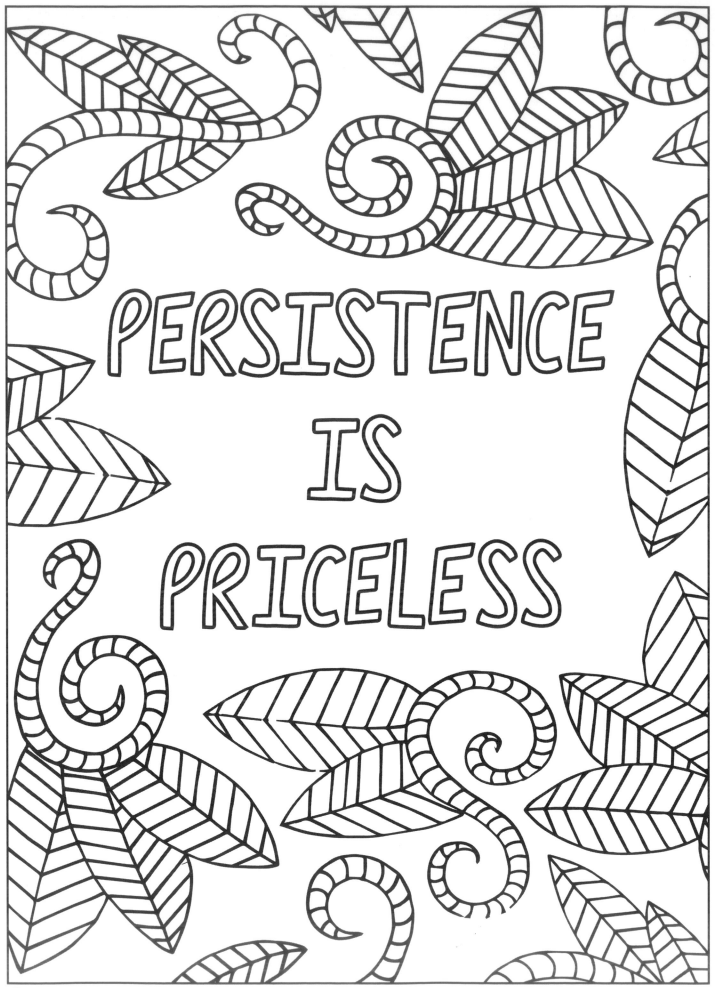

© tut.com

Persistence is priceless, but its value
lies in doing, doing, doing; not in
waiting, waiting, waiting.

OK? OK? OK?

The Universe

Not that you were hanging around for
someone, someway, or somehow.

© tut.com

Always, the best remedy for dealing with
a troubling past is living in the present.

Tallyho,
 The Universe

Not just "being" in the present
(unless you're a tree), but "living" in it.

© tut.com

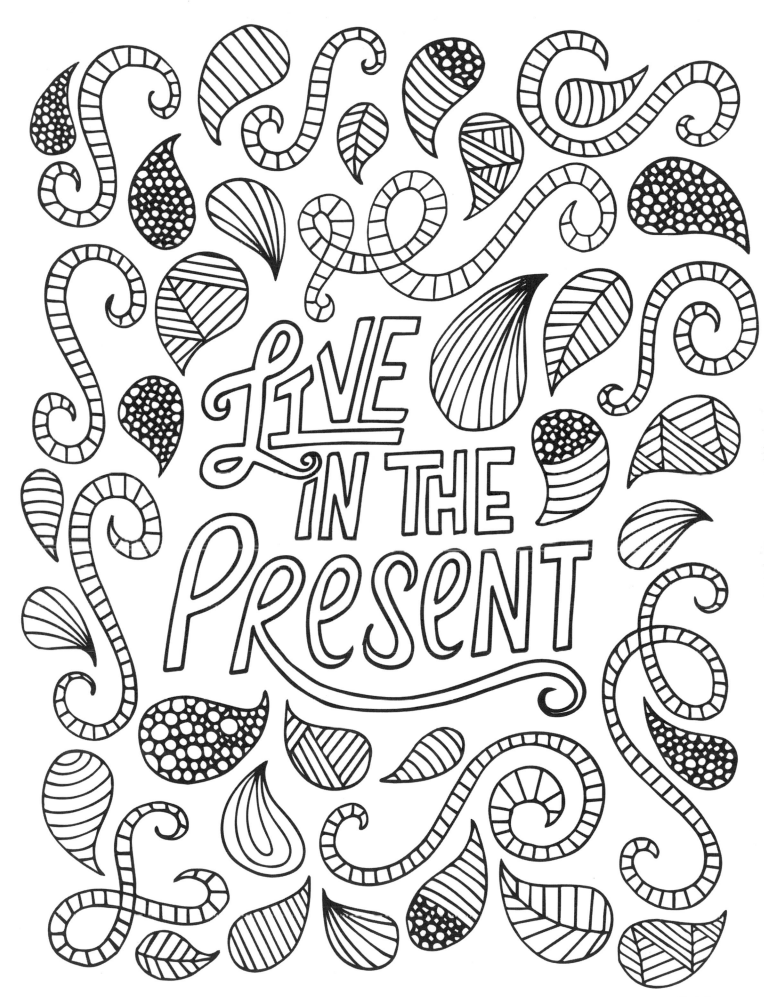

Live in the Present

© tut.com

YOU'VE GOT THE POWER

© tut.com

OK. OK. I confess.

No matter what you're after in life, getting what you want always boils down to at least a little bit of divine intervention.

But then, I'm talking about yours, not mine.

Bada-boom,

The Universe

You've got the power.

© tut.com

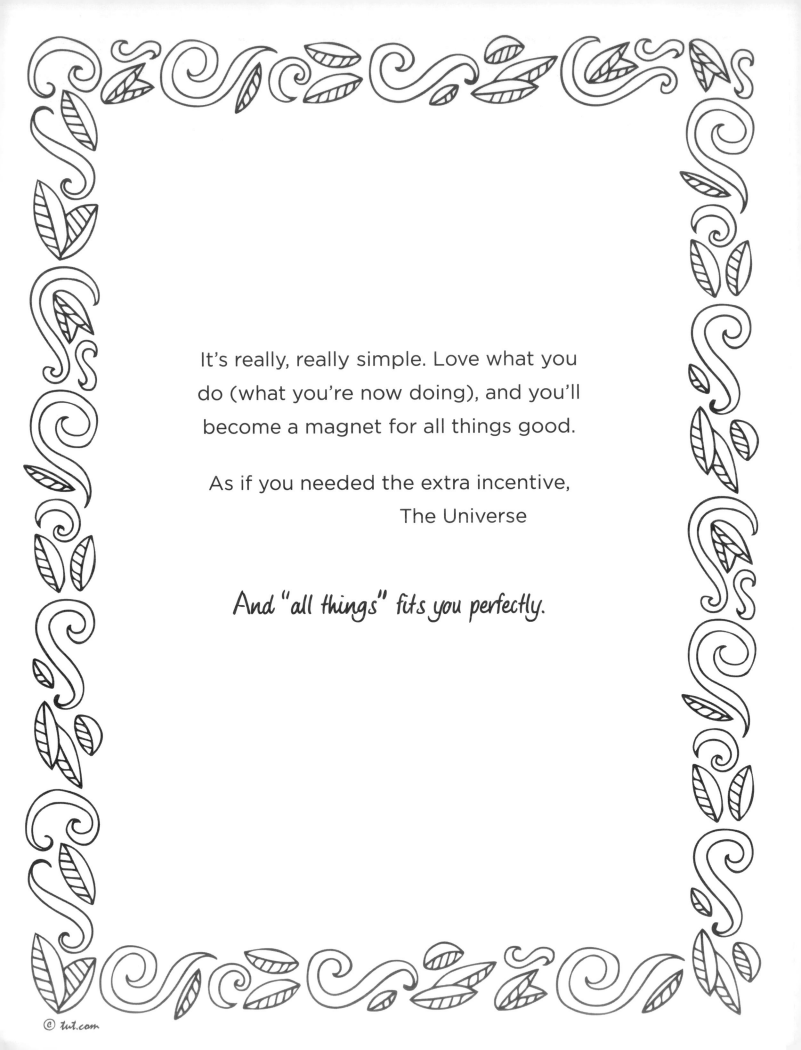

It's really, really simple. Love what you do (what you're now doing), and you'll become a magnet for all things good.

As if you needed the extra incentive,
The Universe

And "all things" fits you perfectly.

© tut.com

LO
VE
WHAT
YOU DO

© tut.com

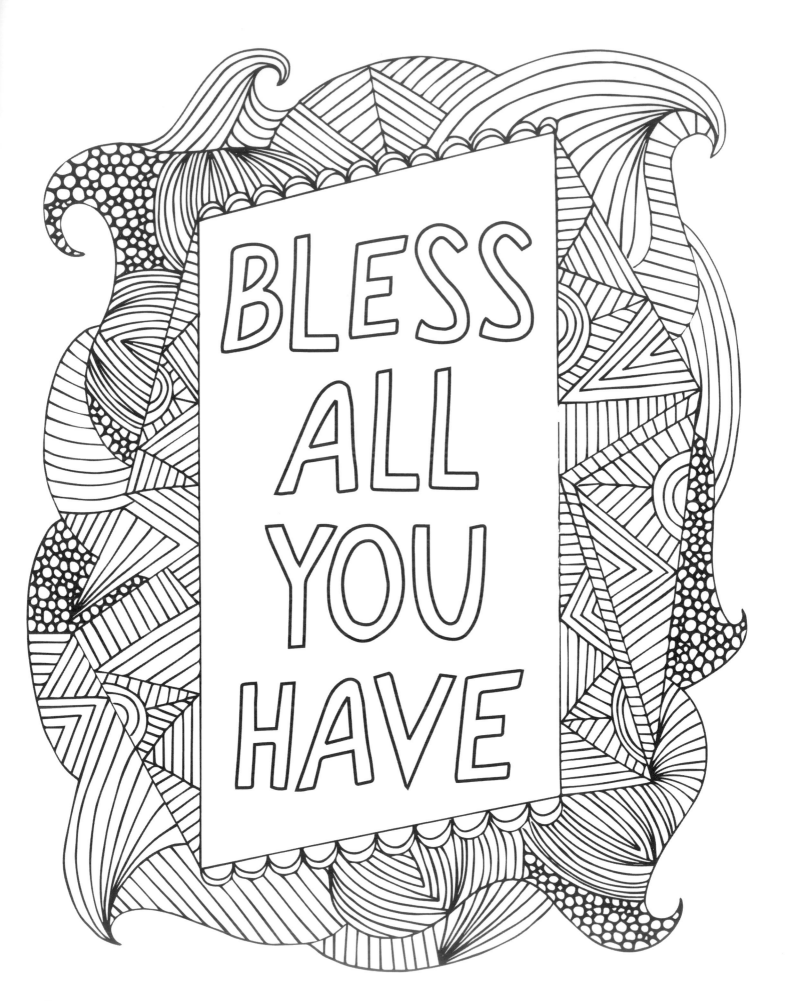

BLESS ALL YOU HAVE

© tut.com

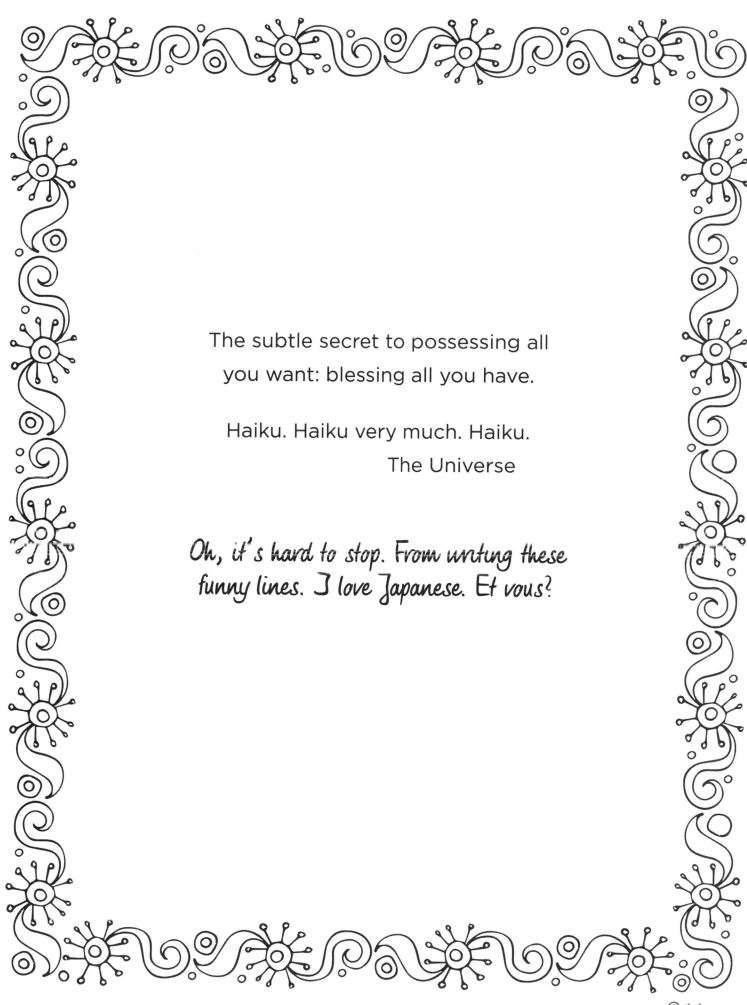

The subtle secret to possessing all
you want: blessing all you have.

Haiku. Haiku very much. Haiku.
The Universe

Oh, it's hard to stop. From writing these
funny lines. I love Japanese. Et vous?

© tut.com

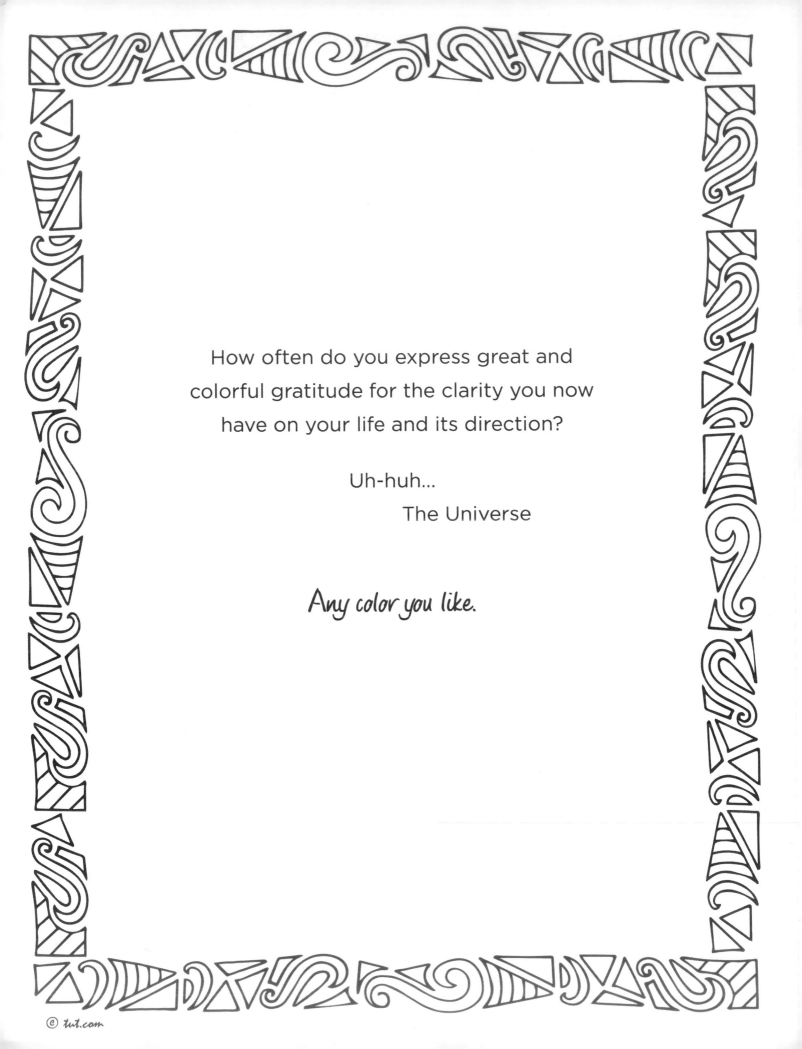

How often do you express great and colorful gratitude for the clarity you now have on your life and its direction?

Uh-huh...

The Universe

Any color you like.

© tut.com

Express

GRATITUDE

© tut.com

© tut.com